DR
500
FANTASTIC
FOODS

A Sketchbook for Artists, Designers, and Doodlers

ZOË INGRAM

Quarry Books
100 Cummings Center, Suite 406L
Beverly, MA 01915

quarrybooks.com • quarryspoon.com

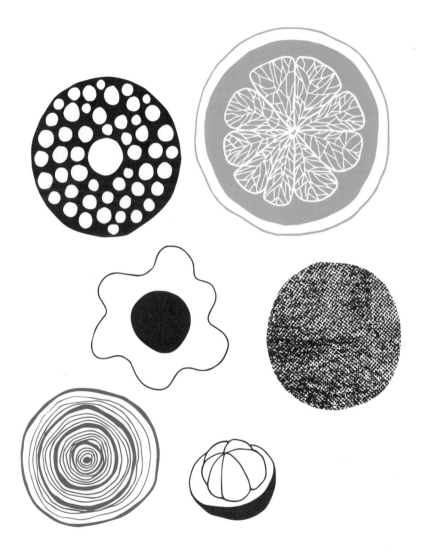

HOW TO USE THIS BOOK

Draw 500 Fantastic Foods is a celebration of all things scrumptious and is designed to help you observe, see, and draw in a fun and interactive way. There is a variety of themes throughout the book, each exploring a different type of food, ranging from the most natural and healthy of foods to naughty but nice sugary treats.

This book will challenge you to look at varied shapes, marks, and lines and give you food for thought on how you might approach your own drawings.

Some spreads have all of the drawings on one page, leaving the opposite page free for you to fill with your own drawings. Some have spaces in between the drawings for you to add your own creative flair.

Why not take a trip to your local market and buy some different types of spices in their original state or some exotic fruits to draw? Do you have a vegetable garden? Do you like to try new foods? Bring your sketchbook along for a lunch date. You can start by replicating some of the drawing styles found within these pages, or use the examples as a launch point for your own unique creations. Remember that there is no right or wrong way to do it. Don't worry about mistakes. Most importantly, just have fun!

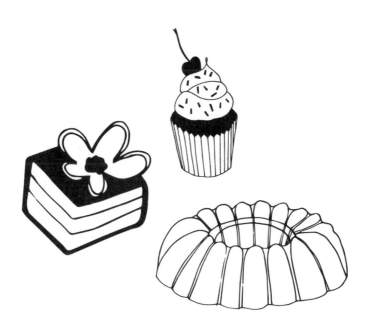

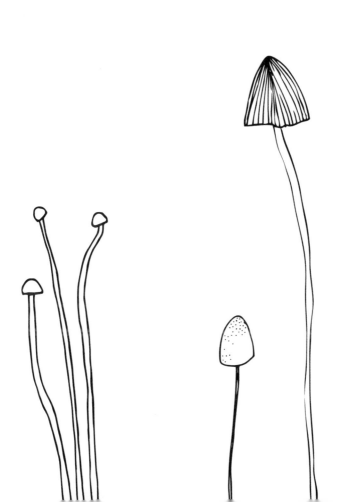

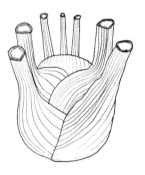

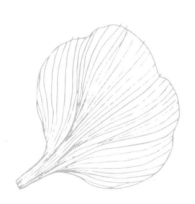

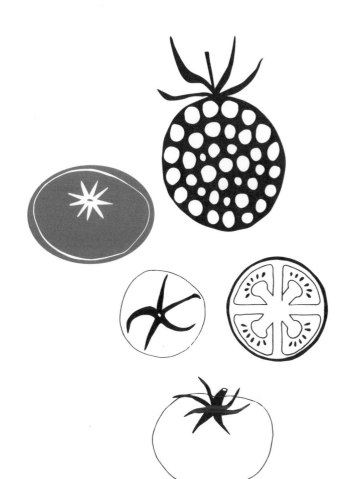

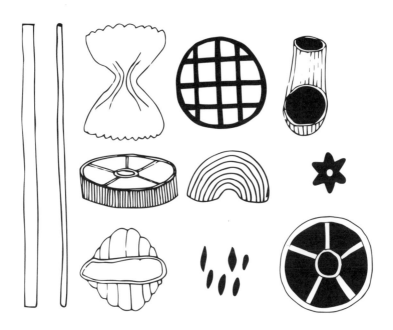

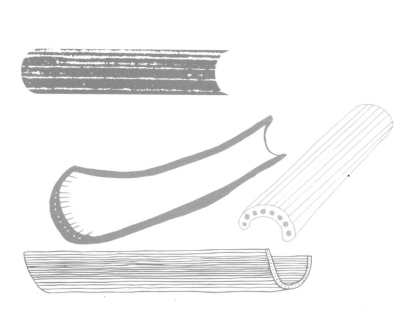

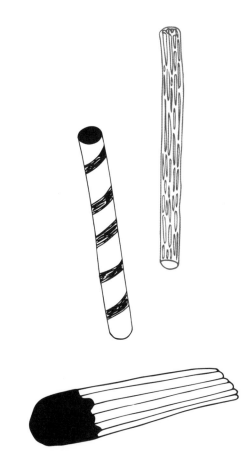

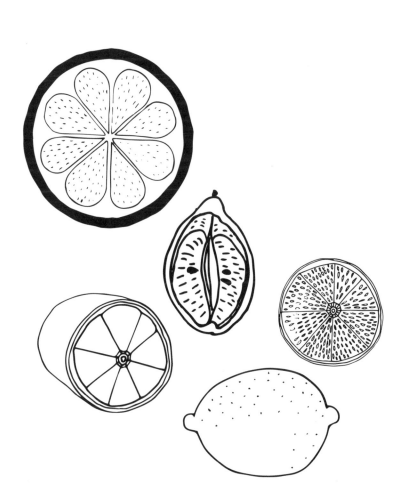

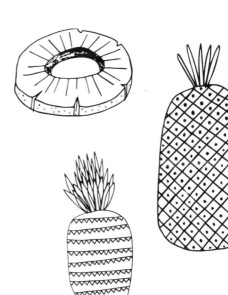

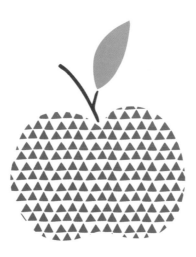

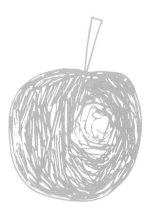

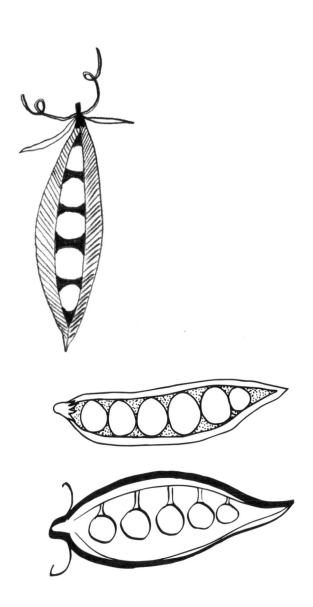

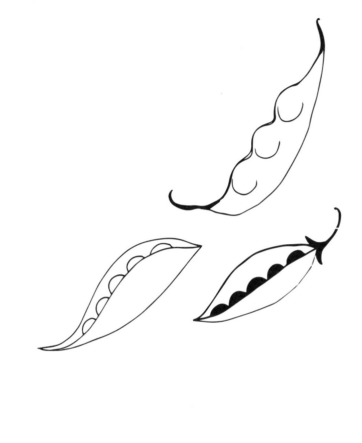

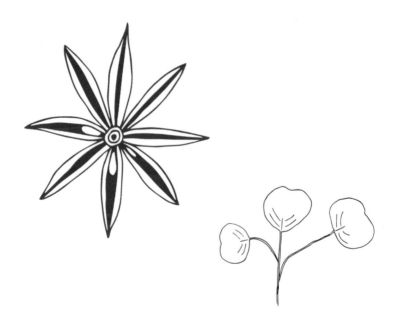

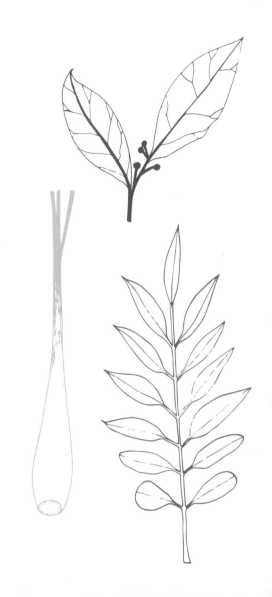

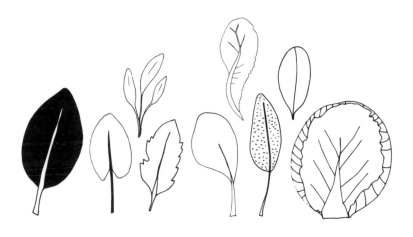

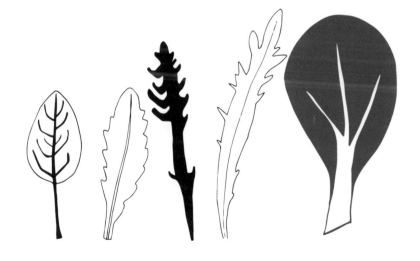

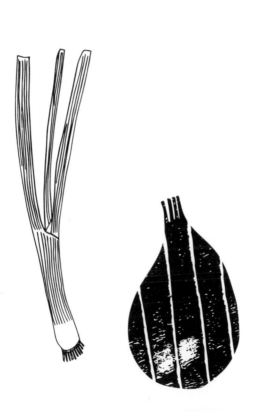

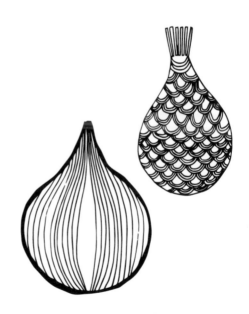

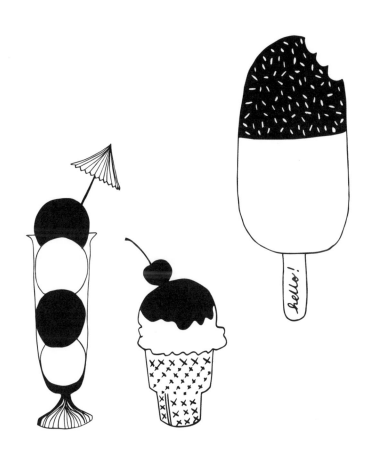

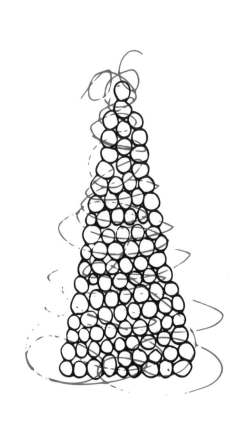

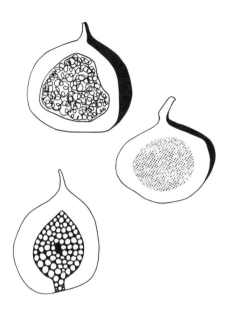

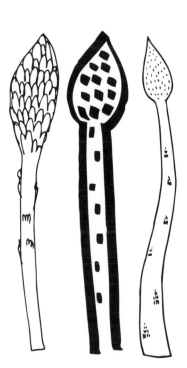

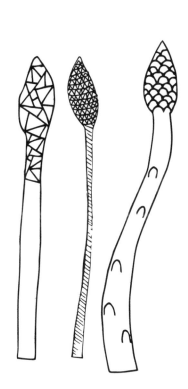

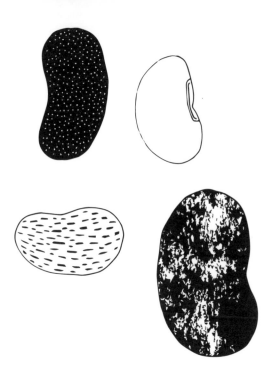

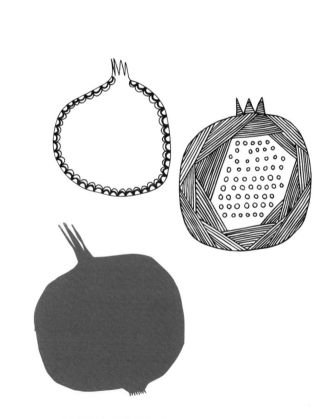

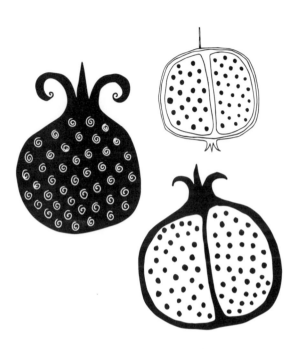

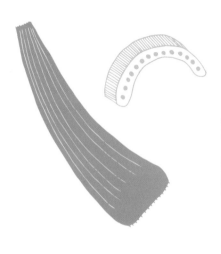

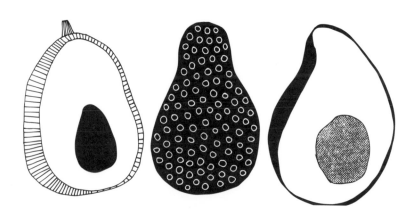

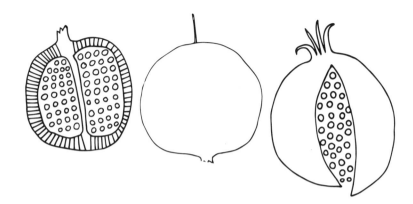

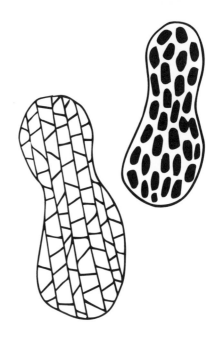

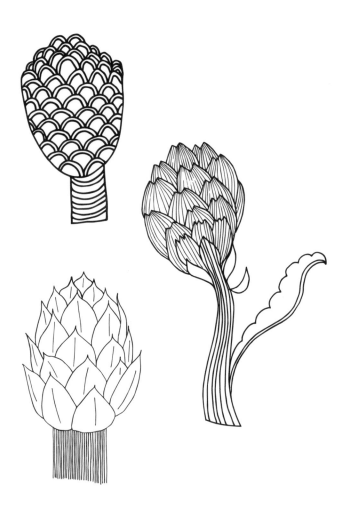

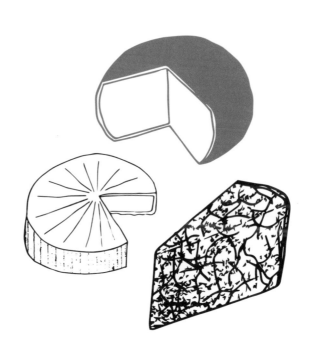

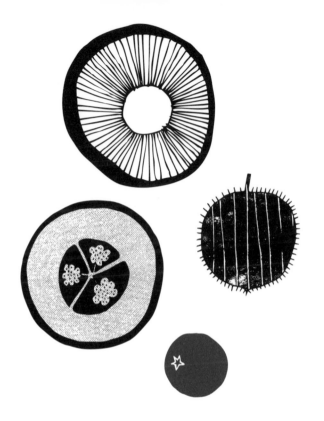

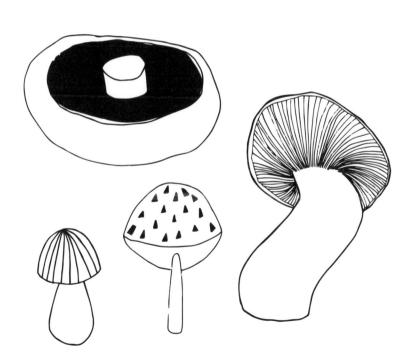

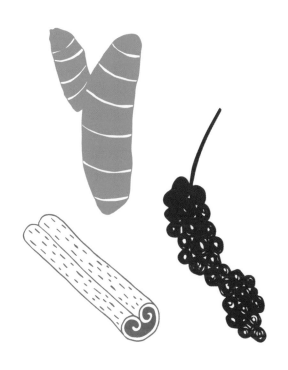

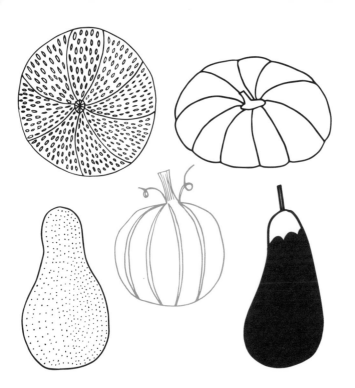

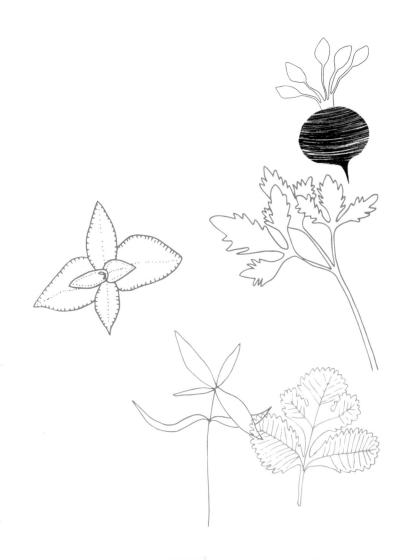

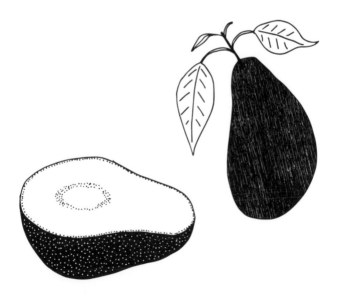

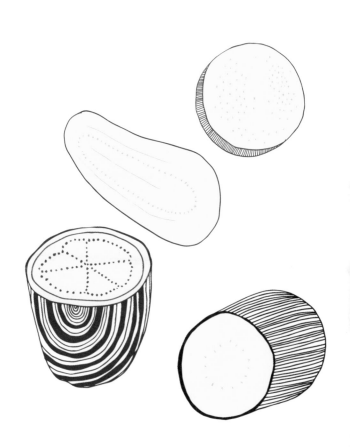

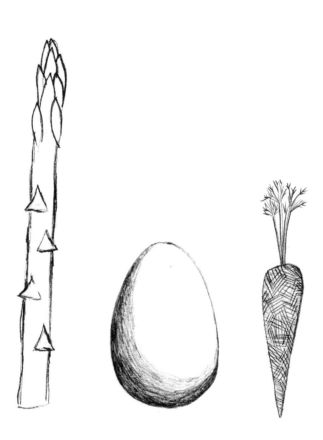

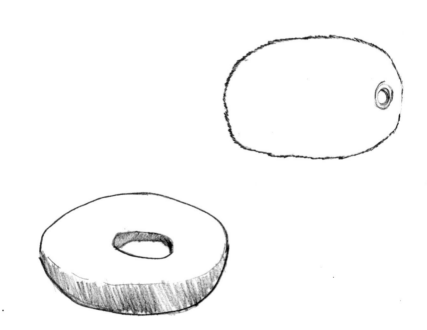

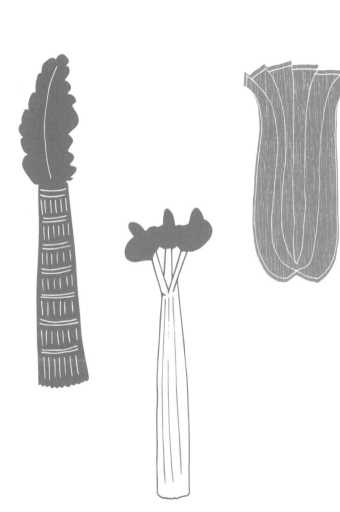

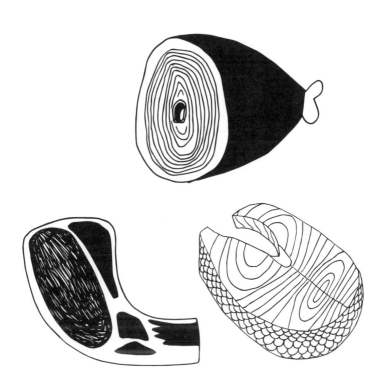

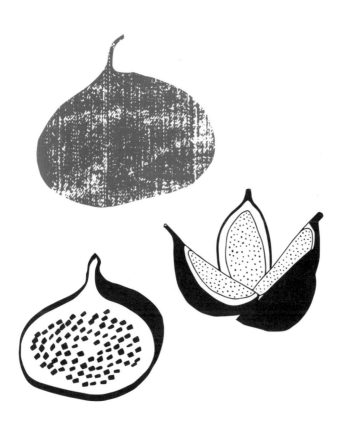

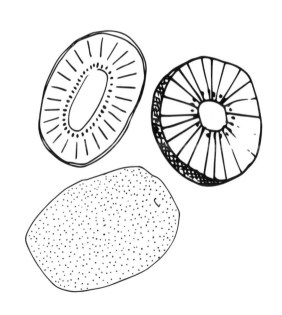

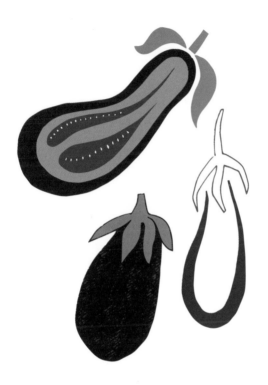

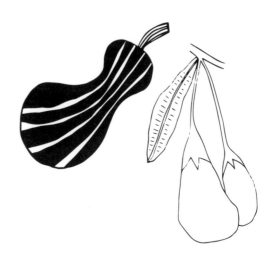
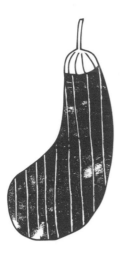

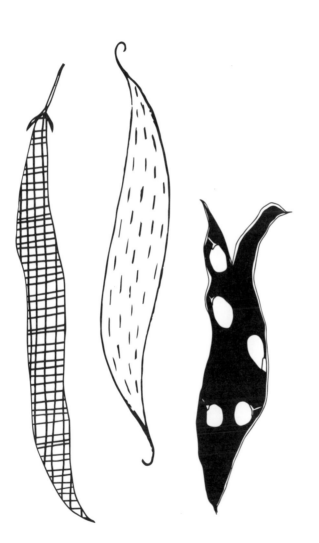

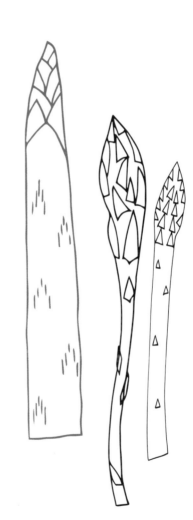

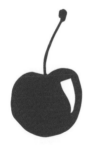

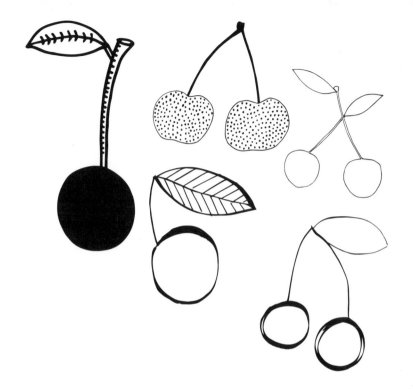

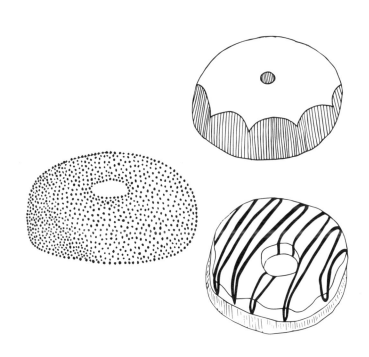

ABOUT THE ARTIST

Zoë Ingram is a designer and illustrator with an honors
degree in printed textile design from the Scottish College of
Textiles. Originally from Edinburgh, Scotland, Zoë now calls
Adelaide, Australia, home. The fantastic weather, food, wine,
and surroundings in South Australia provide her with loads
of inspiration, as do her two daughters. In 2013, Zoë won an
international art competition in conjunction with Lilla Rogers
Studio and has since worked with clients such as Robert
Kaufman Fabrics, American Greetings, and Midwest CBK and is
now represented internationally by Lilla Rogers Studio. She is also
one eighth of a talented group of artists and illustrators in Forest
Foundry, a global art collective.

First published in the United States of America in 2015 by
Quarry Books, a member of
Quarto Publishing Group USA Inc.
100 Cummings Center
Suite 406-L
Beverly, Massachusetts 01915-6101
Telephone: (978) 282-9590
Fax: (978) 283-2742
www.quarrybooks.com
Visit www.craftside.net for a behind-the-scenes peek at our crafty world!

10 9 8 7 6 5 4 3 2 1

ISBN: 978-1-63159-091-7

All artwork compiled from *20 Ways to Draw a Strawberry and 44 Other Elegant Edibles*, © 2014 Quarry Books

Design: Debbie Berne

Printed in China